Artistically Yours

Building Your Professional Face Painting Business

Chances are if you have my book in your hand you are interested in starting a business. Perhaps you are dreaming of a professional face painting business, or maybe a balloonist. Whatever your dream business is, the overall basic steps explained in this book will help you get answers to the many questions you have.

The first thing you need to ask yourself is how far do you want to go with your business? Now that you have thought of that write it down, and make a list of what kind of target you are aiming for. Do you want to paint very young kids, teenagers, adults, or maybe all ages? Do you plan to paint only faces, or go even further with body painting? Lots of things to think about right!

Now that you know what kind of target you are going for begin to think of a business name. When choosing a business name you want to try coming up with an original, catchy name that fits what services you are offering. Write down a few choices. The next thing you want to do is register your business name. Registering your business name can be free or maybe a few dollars. Fictitious business name can usually be registered through your local register of deeds office.

Now you need to determine if you want a sole ownership business, partnership, or corporation. To really understand the differences you should contact your local or nearest Small Business Development Center. Depending upon the type of business, you may need a special license or registration at the city, county or state level. You will need to go online or in person to

your local IRS office and apply for a tax id number; this should be free of cost. This is the number that will go on your business license and be affiliated with your business for tax purposes.

Some other places to check in with as each area is different are as follows:

1. Department of Labor
2. Health Department
3. Business Zoning Office
4. Business Insurance such as liability (most have a million dollar liability policy)
5. Secretary of State (If you are wanting trademark, patent, or Copyright)

Once you have checked with those places just to let them know you are starting your business and just wanted to check with them and see if you need any special permissions, license, or certificates etc. then you are set to move on.

The next step is financing. Do you have startup funds already, or do you need financing? Starting a professional face painting business should not really take a lot if you are just getting the necessary things. If you do need financing, consider family, friends, your bank etc.

Now that you have all the above things figured out, you are going to need to start purchasing supplies for your new business and start to think about your marketing and advertising plan.

Supplies to start your business:

FDA approved cosmetic make up- you can get these from many different companies, some well-known companies are Snazaroo, Silly Farm, Jest Paint, LA Rocks, Cameleon, Face Paint Forum Shop, Paintertainment, Classy Clown, just to name a few. These businesses sale the most current cosmetic make up, as well as gems, brushes, and other tools.

Paint Brushes- you should purchase multiple sizes and types all of which can be found on the business websites mentioned above. Try out and decide for yourself which brands of paint or

brushes you like, the most important thing is that you are buying the safest products and FDA approved.

Brush Holder, Water Holder, Glitter (get the glitter specifically for faces from one of the face painting suppliers) glitter mark liquid bling (optional but nice little extra) Sponges (there are many brands and you can use halves, or even cut them smaller) Stencils (optional but nice to have to add something extra these are also found on most of the face painting suppliers websites) hand held mirror, container of baby wipes, q tips (for applying lip color) foldable table, 2-3 foldable chairs, table cloth with vinyl top, canopy (don't get the cheap canopy get the kind that pop up and are

a little more expensive it will save you money in the long run, and don't put it up if it is super windy) banner (optional, however I recommend having one or a few check your local printing businesses or go online to something like vista print) business cards (make your own at home, check your local printing business or online business such as vista print) Foam pre-cut paint holder (optional)

Having the above will be the basic supplies you need to start working. Some face painters like to have more, some like less. It is really your choice how much you want to start with. Try out a few different brands because you will find the one you

prefer, we all like our own brands. We are all different, and that is OK.

Let's now talk about marketing or advertising. I will say right now, this can be expensive if you let it be. There are many views on which methods work the best. The area you live in might be the difference on which method works best. I will share with you the things I did and how they went for ME. I encourage you to try things and hear advice of other painters too. The first thing I did was make a business page on Facebook, this is my biggest tool, and a great way to keep customers informed on your services, show off your talent, and get gigs. I tried ads in the newspaper, for me they didn't bring in a lot of business, but again it

could be different for you. I had a few ads on the radio; this can be costly but maybe worth it. Good old fashioned flyers put some up around town. All of these can help you get the word out about your new business. I would also consider having some sort of promotional grand opening of your business, set up a booth somewhere and paint faces! Once you start having jobs it really then becomes word of mouth. I think of it like this, you can sit around and wait for the job to come to you, or you can take full control and get the jobs. When I started face painting I thought it was going to be overloaded with birthday parties which was my market at first, I quickly realized that it wasn't going to be like that. If I had sat and waited for phone calls for birthday parties, I'd not be getting

much work. Let me explain more on that as I talk about how to get gigs.

The best way to find gigs is to utilize your resources. The internet is your best friend. Once you have your Facebook business page set up, use the search bar at the top of the screen and start searching vendor events for your area, be sure to include surrounding areas within the travel distance that you are willing to travel. Join these groups and get into some vendor shows, choose ones that have small booth fees, charge per face or per balloon at these types of vendor events. A lot of these types of vendor events will be craft fairs. That is a good place to start so that you get used to how the day on a gig will go and it eases

the stress as it isn't jumping right into a full blown festival type event. Another great resource is applying for all the local and surrounding area festivals, days, fairs etc. I think it is good to graduate from craft fairs to festivals or days. Use your favorite internet search engine to look up these events try typing in the state and then the word events or festivals. As an example I use southdakotamagazine.com and then click on events and get a lot of the entire states events. Then apply to current events, and to future events. It is never too soon to try and get your foot in the door. Most of these events will be pay per face or pay per balloon, unless another business hires you on an hourly basis to be at their city event, in which case the services would then be

FREE to the public. Example, your city Chamber of Commerce hires you to do Potato Days, they pay you $125 per hour, and the parents don't pay. While I am mentioning hourly rate, it is you who chooses your hourly rate. The next bigger thing is having a booth at a fair or multiple day huge festival. These events are HUGE, you're going to most likely be busy the entire time, and have a long line. If you decide you want to get into these kinds of events there are pros and cons. Money is the pro, you are going to make a lot of money whether it is pay per face or hourly rate (if the fair hires you on an hourly basis). The biggest thing with a fair is to plan, double check your supply list, maybe bring help, and have your fast festival designs or balloons on display. Most artists will tell

you not to attempt full face, detailed designs at a fair simply because you are going to want to shoot for 4-5 minutes per face.

A lot to think about right? Just remember you are your own boss, you choose the gigs you want, accept the gigs you want, and decline what you aren't ready for. Do what is comfortable to you, and don't put yourself in a position that is only going to stress you out. Some people are great in the busiest crowded situations, and some prefer the more laid back. I am kind of in the middle myself. Once you are well known in your area, you will start to get more and more calls for birthday parties which seem to be pretty smooth sailing unless it's a huge party crammed into a too small

time slot. Other things to consider are charity events, yearly FREE events to get your business name out there, and providing your services to local restaurants on kid's night. If you want more of a teenager crowd, talk to the schools about their events and dances. Lastly, all of the holidays and the events that come with them are great things to get into, as well as your local parades, rodeos, races etc. The sky is the limit!

Now, let's talk money! How much should you charge for your services? The best thing to do, is consider where you are at in your talent, are you not so good, getting better, great, or very experienced? Now Google your competition in your area, look at their work, if they make their

fees public look at what they charge. Use common sense in setting your prices taking into consideration all of the above. The good thing is as you grow, and get better you can increase your prices! I increased my prices probably three times in the first year. Consider other artists in your area, hear their advice, but you make the decisions that you want. Figure out if you want to do mostly pay per face, or hourly. If you live near a lot of other painters it is good to make friends, if they are mature, and friendly it could be a great, as you can pass on gigs to each other, learn from each other, and also share valuable information. Some towns where there are a lot of painters, they try to do things similar especially if they have rates set and on an hourly basis and then a new painter

comes a long and charges pay per face or way cheaper it ends up harming all of your business because obviously folks will want cheaper prices and everyone then loses money. Be competitive in comparison, but don't go way cheaper. There are great friendships in the face painting community; however that doesn't mean you won't run into a not so friendly competitor.

So, how about learning, practicing, and meeting other painters or balloonists. I think this is huge in our profession. It is better to socialize with likeminded individuals, share with each other, and learn from each other. If you live in an area with lots of competition then use that to your advantage. Make Facebook groups, or organize

jams and workshops, this way you can learn and grow in your face painting and balloons. Search Facebook and Google your area; also use the internet to your benefit. There are many resources online to learn from something as simple and free as YouTube (be careful some aren't the best tutorials) however there are some fantastic ones. Check out FabaTV online there is a fee for yearly subscription but totally worth all the knowledge, and they do have occasional FREE live videos with well-known fabulous painters. Silly Farm has some great tips and information definitely use their website. Now there are some fantastic face painters that you will hear of right away once you really get into face painting, I mean more than I could probably mention. These artists have many

workshops and travel around doing them; you can have them come to your area! I definitely suggest attending some because there is no better way to grow than to get hands on face to face training from such amazing artists. I was inspired by Gina Niemi from Grants Pass, Oregon. Gina is an amazing face and body painting artist as well as a phenomenal workshop instructor. I have attended and hosted workshops with her and hope to attend more, find Epic Body Art on Facebook or Fantasy Face Painting those are both Gina Niemi. Not to say there aren't many other great artists because there are, Gina is one that I know well and really admire. Now, other than the above options, I would practice as much as possible on your kids, or neighbor's kids, or your relative's kids

and even practice tear drops and swirls and line work on your own arm. Practice will make perfect. As time goes on look at old work and new work, you will surely see a huge improvement.

How about some words of encouragement! I would like to just start saying that I am fairly new to the profession but have had great success so far, and have become really passionate about face painting and ballooning. I am not perfect, and don't claim to be, but I try my hardest at what I do. My husband Jason Mount and I, run our business. I paint, and he does balloons. I was able to quit my full- time job within only 6 months and now make more with my business than I did with my full-time job. You can do this too, if you put

your heart into your business and really follow the steps I've explained. I feel like if you find you are passionate about whatever kind of business you run, it will be successful. Be kind to others, smile, use your art to make others happy, and karma seems to pretty much be good to you. Remember that you can't wait for things to fall into your lap; you have to chase your dreams, and in the same way go get your gigs and let everyone know who you are and what you do. Pretty soon you will start hearing people talk about the wonderful new business in town! Care about your reputation, be professional, and remember to show professionalism when doing gigs because let's face it, customers like friendly business owners, not grumpy ones. A little something I like to say to

myself is the three R's. Resources, Referrals, Repeat. If you use your resources, you will get referrals, and most of those will repeat having your business at their event.

Let me ask you a question. Are you ready to make your business dream come true? Are you ready to be your own boss, set your own hours, make unlimited income, and all the while be able to be with your family during the week? Sounds a little great right! I am here to tell you from firsthand experience that you can do it, and I am here to help you in any way I can, and share all the resources that I know. I would love it if you find me on Facebook to let me know how this book helped you, or inspired you. I would love to watch

your business dreams come true and follow you on Facebook. I am Wishing Wells Reflections based in South Dakota; I wish you all the success in the world and hope to see you face painting and ballooning soon!

From my family to yours congratulations on your new business journey!

Artistically Yours

I would like to dedicate this book to all the talented individuals on the Midwest Face Painters and Balloonist group on Facebook. All of your heart felt sharing, stories, and tips inspired me in writing this book. I would like to thank Gina Niemi of Epic Body Art and Fantasy Face Painting for inspiring me daily with your amazing art, advice, and words of encouragement, if I hadn't met you I might not be where I am today. I would like to thank Annie the Clown in Southern Oregon for doing such a wonderful job at my kids birthday parties and also inspiring me. I would like to thank Tappy's Face Painting & Balloon Art in Wisconsin for her support, friendship, and inspiring me with her amazing talent, and being one of the most

friendly people I've known. I would like to thank my customers in South Dakota, North Dakota and Minnesota for your support and continued use of our business, I never knew how a small town celebration was until I moved to South Dakota. I would like to thank all of the artists that share their knowledge on the internet, and take time out of their lives to make video tutorials, without artists such as yourself, new aspiring artists would have a difficult time learning. I would like to thank my husband and kids for letting me practice on them so much so that I could grow artistically. To my dear husband, you have been so supportive and I couldn't run this business the same without you. Last but not least, nothing in my life would be possible without my heavenly father, I give credit

to God for everything in my life and for carrying me through the good and hard times. I hope this book helps the new face painters and balloonists get started with their new business, and the things I haven't hit on that is where your resources come in, remember to use them. Lastly, don't ever get too comfortable in your knowledge because there is always much more to learn, one can always keep improving.

www.ingramcontent.com/pod-product-compliance
Lightning Source LLC
Chambersburg PA
CBHW071604170526
45166CB00004B/1793